Gay
Betrayals

Afterall Books

Hannah Quinlan & Rosie Hastings / Leo Bersani

Two Works

GAY BETRAYALS
LEO BERSANI

This edition of 'Gay Betrayals' reproduces the text published in
Is the Rectum a Grave? And Other Essays, Chicago and London:
The University of Chicago Press, 2010. The essay is a revision of
'Trahisons gay', presented at a colloquium at the Centre Pompidou,
Paris, 23 and 27 June, 1997. Reprinted by Permission of The University
of Chicago Press.

With an imagination for surveillance that would have at once appalled and delighted Michel Foucault, some of the far-right groups in America sympathetic to the antigovernment fury apparently behind the 1995 bombing in Oklahoma City have come up with an amazing suggestion. According to them, the federal treasury has marked all the bills it issues in ways that make it possible for FBI agents to drive by anyone's home, point the appropriately attuned electronic device toward a front window, and immediately determine how much money, at that moment, is inside the house. The pecuniary inflection of this paranoid fantasy is perhaps characteristically American. We enjoy comparatively low income-tax rates, and yet a promise to lower taxes even more works like magic in an election campaign. It is therefore not unsurprising that few scenarios of panoptic surveillance evoke such dread as the daily monitoring of our cash assets. But the driving force behind this fantasy is not, or is not principally, economic insecurity. The invasion of financial privacy is, for the groups in question, only an especially ominous manifestation of another invasion: that of their identity. The federal government is the enemy of its people's particularities, whether these be religious, geographical, ethnic, racial, or class-determined. Put this way, the fantasy may strike many of us as not entirely mad, although the particular aberration of those fearful for the integrity of their dollar bills is to assert that sinister governmental monitoring is principally aimed at the white Christian majority. This could of course be thought of as a triumph of the powerful right wing of the Republican Party, which has managed to convince a significant minority of Caucasian Americans that their grievances – often quite justified – are not caused by the Republican crippling of social services that only the federal government can provide, but are rather the result of federal activism, an activism motivated by a sinister identity-plot, a conspiracy at once Jewish, black and homosexual, designed to eradicate white, Christian, straight identity.

Identity-politics is far from dead. Today the notion of community – and now I'm by no means speaking only of the United State – is supported by, indeed often seems grounded in a terror, at times paranoid, at other times realistic enough, at the loss of an identity conferred by belonging to a community. Identity *is* communitarian. Politically reactionary Christian fundamentalism shares with other more seriously besieged minorities a conviction that the

most precious values of life are definable in communitarian terms. Not only that: repression by the majority itself is identitarian. It's always my difference against your difference. In education, the defense of the Western artistic canon is just as much a defense of a cultural identity as, for example, the Chicano or gay studies programs against which, in American universities, such defenses are mounted. The value attributed to universalism, as we can see in France, can itself be a defining trait of a particular cultural identity, and when a society as culturally homogeneous as France is menaced by the heterogeneous, we see how easily a certain language of universalism becomes the defensive weapon against the proximity of a recalcitrant otherness. A universalist ideology lends itself to the imperialist promotion of a specific culture. Confrontation is inevitable, and irresolvable, as long as we debate the relative values of different cultural identities. Perhaps the only way to negotiate and ultimately end the conflict is through an effort for which few of us seem as yet prepared: the effort to rid ourselves not exactly of cultures (an impossible enterprise in any case), but rather of our belief in the inherent value of any cultural identity whatsoever. What if there were no sides to be taken in conflicts of cultural identity? There should perhaps be only a potentially explosive insistence that the value attached to such identities is nothing more than the disposable waste of their history.

These remarks could easily appear to be at odds with my principal argument in *Homos*. There I protest against the de-gaying of gayness, and the protest could be thought of as a way of reaffirming the value of a gay identity. Indeed, the book grew out of my perplexed sense that the unprecedented gay visibility of recent years has been accompanied by a willed invisibility on the part of those presumably most anxious to make themselves visible. A paradoxical relation to the notion of a gay or homosexual identity – at once proud and self-erasing – makes the cultural politics of gays and lesbians, or of queers, a particularly fertile ground in which to raise the issues of identity evoked a moment ago. In richly troubled fashion, queers have at once empowered and invalidated identitarian politics. And by simultaneously proclaiming pride in a gay and lesbian community and making that community essentially unidentifiable, queer thinkers have brought into sharper focus than ever before the problematic nature of what we nevertheless continue to take for granted: the very notion and value of community itself. And it is in doing that

that queers should command the attention of straights – that is, not because we have anything to tell them about the value of relationships or community (something that might help to rescue them from what we glibly talk about as the hell of 'compulsory' heterosexuality), but rather because of our exemplary confusion. Our implicit and involuntary message might be that we aren't sure of how we want to be social, and that we therefore invite straights to redefine with us the notions of community and sociality.

These issues were raised, in rather different ways, by Foucault, and to a large extent the arguments in *Homos* are an ambivalent response to some of his work. He has done more than any other modern writer to both enrich and confuse our thinking about homosexuality and how we might define and work toward a gay community. Chapter 3 of *Homos* begins with a discussion of remarks by Foucault that seductively and dangerously simplify the questions just raised. In a 1982 interview for the American magazine *Salmaqundi*, Foucault said: 'I think that what most bothers those who are not gay about gayness is the gay life-style, not sex acts themselves. ... It is the prospect that gays will create as yet unforseen kinds of relationships that many people cannot tolerate.' There are three assumptions in Foucault's claims that have been important in queer theory. First of all, homosexual sex is not what is threatening about homosexuality. Second, there is nothing to interpret in homosexual desire and, by implication, no homosexual character shaping such desire. Third, gays are more dangerous politically *without* an analyzable identity. It is the remarkable result of Foucault's argument that no one wants to be called a homosexual – an aversion most striking on the part of self-identified homosexual activists and theorists. Monique Wittig has claimed that 'it would be incorrect to say that lesbians associate, make love, live with women'; for Judith Butler, the only thing lesbians have in common is a knowledge of how homophobia works against women; and Michael Warner argues that queerness is characterized by a determined 'resistance to regimes of the normal.' The extreme distrust of all self-identifying moves evidenced in such remarks is understandable. The elaborating of erotic preferences into a character – into a kind of erotically determined essence – is, as Foucault forcefully argues, inherently a disciplinary project. Panoptic vision depends on a successful immobilizing of the objects it surveys; only then can behavior be transformed into manipulatable characterological types.

And yet the way in which the Foucauldian suspicion of sexual essences has been picked up by queer theorists has made me almost nostalgic for those very essences. The principal critical argument of *Homos* is that gay men and lesbians have nearly disappeared into their sophisticated awareness of how they been culturally constructed as gay men and lesbians (which is not to deny the importance of cultural construction in the attribution to us of such things as a gay sensibility). And the consequence of self-erasure is … self-erasure, the elimination of gays – the principal aim of homophobia. An acceptance, a promotion of a certain homosexual specificity may be necessary in order for us to be as dangerous culturally, and ultimately politically, as many of us would like to be. Might same-sex desire be transgressive not simply of sexual customs, but, more radically, of the very notions of relationality in which such customs are grounded? Furthermore, the anti-identitarian critique needs to be qualified. It is not at all certain that modern typologies, genealogies, and schemes of desire are necessarily more essentializing than earlier sexual classifications on the basis of behavior alone (rather than some fixed inner disposition). The ancient Greek model, as both Foucault and David Halperin describe it, made for a brutal reduction of the person to his sexual behavior: phallic penetration of another's body not only expressed virility but also was a sign of social superiority, an expression of something we might call the (male) citizen-essence. This binary model is a striking example of the misogyny inherent in homophobia, even though it was not opposed to homosexuality per se. In a sense, the Greeks were so open about their revulsion to what they understood as female sexuality, and so untroubled in their thinking about the relation between power and phallic penetration, that they didn't need to pretend, as nineteenth-century sexologists did, that men who went to bed with other men were all secretly women. Only half of them were women, and that judgment had enormous social implications: the adult male citizen who allowed himself to be penetrated like women and slaves was politically disgraced. Even the crudest identity-mongering leaves us freer than that. To be a woman in a man's body can certainly be thought of as an imprisoning definition, but at least it leaves open the possibility of wondering, as Freud did, about the various desiring positions a woman might take. While psychoanalysis has played a major role in the essentializing of desire, it has also initiated an anti-essentializing inquiry into the nature of desire. There is no reason

to be as suspicious of such inquiries as Foucault was, for they have helped us to see that the mobility of desire defeats the project of fixing identity by way of a science of desire. That mobility makes impossible correlations the Greeks found easy to make: most notably between on the one hand, penetrating or being penetrated by another person and, on the other, attributions of moral and political superiority and inferiority.

This, however, is not what I was principally interested in demonstrating in *Homos*. Important work has been done by others that shows, first, that psychoanalytic genealogies of desire may actually destroy rather than reinforce normative views of sexuality (the teleology according to which heterosexual genitality is the normal, mature end-point of sexual development) and, second, that the specificity of same-sex desire puts into question the very category of same-sex desire (because, precisely, of the gender-bending variety of desiring positions inherent in homosexual fantasy). In the context of the de-gaying – the gay and lesbian disappearing act – I began by examining, psychoanalysis proposes a mode of nonessentializing, always provisional psychic visibility. It suggests a specificity of both origin and movement in gay desire, a specificity quite different from the fixed identity constructed by disciplinary networks of power. However, given the necessarily uncertain nature of all etiological investigations of desire, and their tendency to harden into dogma (even presumably liberating dogma), I'm not interested in committing myself to a stable definition of gay desire. Or, more exactly, such a definition is useful, perhaps even necessary, insofar as we investigate its relational implications – by which I mean the continuities between desire and community, between our sexuality and the ways in which we imagine sociality.

The psychoanalytic inquiry can be politicized in ways generally not allowed for by queer theorists. Like Eve Sedgwick, most of these thinkers feel that accounts of the origin of sexual preference and identity in individuals run counter to politically gay-affirmative work. The trouble is that gay affirmation has become a tame affair, which is perhaps inevitable when we are that suspicious of sexual identities. Queer rhetoric, as in Butler's definition of lesbians as people who know how homophobia operates against women, can be deliberately inflammatory, but in rejecting the sexual specificity of queerness we have become

more and more inclined to define our communitarian goals in terms provided by the homophobic community. It seems at times as if we can no longer imagine anything more politically stimulating than to struggle for acceptance as good soldiers, good priests, and good parents. While I remain enough of a liberal to believe that we should defend people's rights to serve whatever worthy or unworthy cause inspires them, I'm more excited by some glorious precedents for thinking of homosexuality as truly disruptive – as a force not limited to the modest goal of tolerance for diverse lifestyles, but perhaps even mandating the choice of an outlaw existence. That choice (which I'll elaborate on in a moment) would be quite different from what currently passes for queer politics. Suspicious of any enforced identity, gays and lesbians play subversively – a word I've come to distrust, since it doesn't seem to mean much more than engaging in naughty parodies – with normative identities, attempting, for example, to resignify the family for communities that defy the usual assumptions about what constitutes a family. These efforts can have assimilative rather than subversive consequences; having de-gayed themselves, gays melt into the very culture they like to think of themselves as undermining. Or, having 'realistically' abandoned what Steven Seidman, in his essay for *Fear of a Queer Planet*, calls a 'millenial vision' of dominations's demise, we resign ourselves to the micropolitics of local struggles for participatory democracy and social justice – not shying away, as Seidman puts it, 'from spelling out a vision of a better society in terms resonant to policy makers and activists.' We thus reveal political ambitions about as stirring as those reflected on the bumper stickers that enjoin us to 'think globally and act locally.'

Curiously enough, the assimilative tendency seems to coexist quite comfortably with what might seem to exclude it: gay and lesbian self-identification in terms of other oppressed minorities. The aversion to homosexuality as an identity has made us into identity-floaters: we wish to both join the ranks of a heterosexual, family-oriented society and identify with the disenfranchised people truly marginalized by that society. In their yearning to be subversive, white middle-class gay men in particular have tended to either blur the differences between themselves and other groups demonstrably more oppressed than they are or suggest that those differences could be overcome by acts of political good faith. The relation of gay men to feminism, for example, and in

particular to lesbian feminism, is bound to be more problematic than we like to admit. It's not simply that a white male, straight or gay, is more likely to enjoy privileges in our society than, say, a black lesbian. We're willing enough to admit that; what's more difficult to admit is our erotic complicity with the distributors of power, with the ways in which our society defines the sexiness of power. In 'Is the Rectum a Grave?' I argued against a tendency among gay activists to ignore the connections between political sympathies and sexual fantasies and activities. There can be, I argued, a continuity between a sexual preference for rough and uniformed trade, a sentimentalizing of the armed forces, and right-wing politics. At the very least, our feminist sympathies will perhaps always be complicated by a narcissistic investment in the objects of our desire. In his desires, the gay man runs the risk of identifying with culturally dominant images of misogynistic maleness. A more or less secret sympathy with heterosexual male misogyny carries with it the narcissistically gratifying reward of confirming our membership in (and not simply our erotic appetite for) privileged male society. The fantasy underpinnings of gay men's feminism become particularly fraught when our feminist allies are lesbians. Indeed, it's not difficult to appreciate why 'fantasy' has become, in certain activist circles, a politically suspect word. If we think of how remote lesbian desiring fantasies are, by definition, from gay male desiring fantasies, and if we acknowledge the influence of erotic investments on political choices, then the very notion of fantasy could easily seem like a heterosexist scheme to sow discord in the gay and lesbian community.

Queer critiques of homosexual identity have generally been desexualizing discourses. You would never know, from many of the works I discuss in *Homos*, that gay men, for all their diversity, share strong sexual interest in other human beings anatomically identifiable as male. Queer studies frequently takes the sex out of being queer. 'Queer' is preferred to 'gay', Michael Warner has suggested in *Fear of a Queer Planet*, in large part because of its sexually indeterminate reference; it becomes a universal political category, embracing every one who resists 'regimes of the normal.' (Since many gay men apparently feel quite comfortable with those regimes, would they, unlike many radical straights, be excluded from queerness?) At the same time, gay literary studies, for example, is tireless in its pursuit of what is

called homoeroticism in an astonishing number of significant writers from the past. We end up with the implicit but no less extraordinary proposition that gays aren't homosexual but all straights are homoerotic. Given the terminological and epistemological confusion all this creates, it might not be a bad idea to drop the very category of homoeroticism, since it seems to me to be little more than a provokingly tendentious way of asserting a certain sexual indeterminacy in all human beings, a state of affairs hardly discovered by queer studies. The confusion and the denials are all the more unfortunate since queer studies does, as Warner emphasizes, set out to make sexuality 'a primary category for social analysis.' But, with a few exceptions, this has merely added another category to the analysis of social institutions (making explicit the prescriptive assumptions about sexuality embedded within institutions) rather than trying to trace the political productivity of the sexual. If queerness is to mean more than simply taking sexuality into account in our political analyses, if it means that modalities of desire are not only effects of social operations but are at the core of our very imagination of the political and the social, then something has to be said about how, in gay sexuality for example, erotic desire for the same might affect, even revolutionize, our understanding of how the human subject is, or might be, socially implicated.

It seems to me that the writers I discuss in *Homos*, especially Genet and Gide, address this question. I chose them not because they are relevant to specific policy issues that we might face today, but rather because they propose what are for the moment necessarily mythic reconfigurations of identity and sociality. Alongside the indispensable work, for example, that has been done in AIDS activism, we might also want to think about the ways in which a radical gay or queer politics might emerge not only from a horrendous episode in medical history in which we have been among the principal victims, but also from a gay specificity not dependent on such tragic contingencies. Queer politics has been mainly a micropolitics focused on particular issues which there is no reason to believe will ever be exhausted if the fundamental types of community and relationality out of which such issues spring are not in themselves questioned and redefined. And this activity has to be, at least for the moment, an activity of the intellectual imagination, one for which the micropoliticians often have no use or patience but which seems

to me as indispensable, no more of a luxury, than our immediate
and vital concrete struggles.

At his or her best, the homosexual is a failed subject, one that needs
its identity to be cloned, or inaccurately replicated, outside of it.
This is the strength, not the weakness, of homosexuality, for the
fiction of an inviolable and unified subject has been an important
source of human violence. Each monad-like subject – whether it
be a personal, ethnic, national, or racial subject – feels obliged
to arm itself against the difference embodied in other subjects
equally determined to defend their 'integrity' against the Other.
It seems that the only way we can love the other or the external
world is to find ourselves somehow in it. Only then might there be
a nonviolent relation to the world that doesn't seek to exterminate
difference. The homosexual, perhaps even the homosexual as a
category (what I have called 'homoness') rather than as a person
(for very often the culturally elaborated differences between
the sexes are reconstituted and played out between two men or
between two women) might be the model for correspondences
of being that are by no means limited to relations among
persons. Indeed, the human itself has no ontological priority
here. Homoness can first be experienced as a communication
of forms, as a kind of universal solidarity not of identities but
of positionings and configurations in space, a solidarity that
ignores even the apparently most intractable identity-difference:
between the human and the nonhuman. The apprenticeship for
a relationality founded on sameness rather than on difference
must perhaps first of all be a perceptual apprenticeship (in which
art can play a central role) in correspondences that participate
in a single but vast family of forms in the universe. This may
even involve (as it does explicitly in Genet) what appears to be a
betrayal, a radical anti-relationality that may be the prerequisite
negativity for an anti-identitarian community. In homosexual
sociality, it is perhaps our antimonogamous promiscuity that
best approximates this relational betrayal, a truly gay betrayal
that frees us from some of the benefits of a social assimilation to
which some of us understandably but no less sadly aspire.

HANNAH QUINLAN & ROSIE HASTINGS

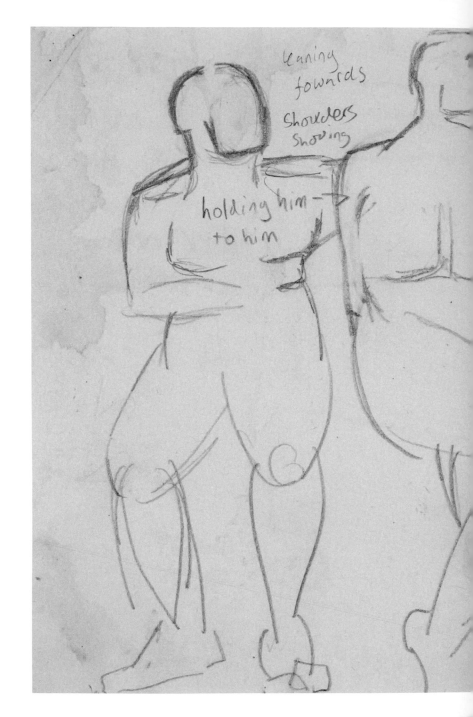

leaning
towards

shoulders
showing

holding him →
to him

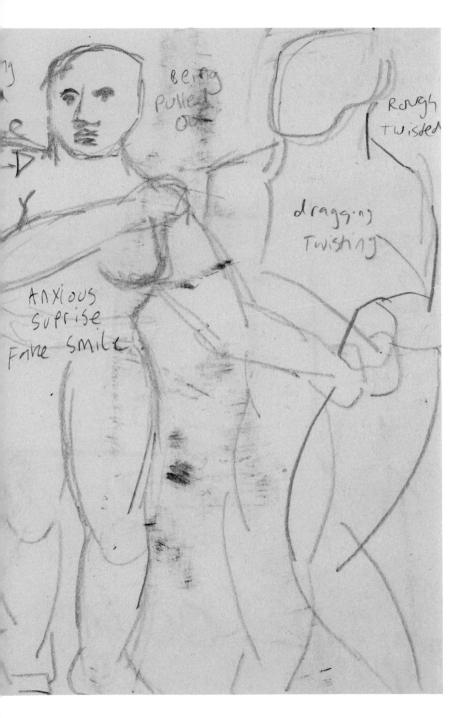

Being
Pulled
Out

Rough
Twisted

dragging
Twisting

ANXIOUS
SUPrise
Fake Smile

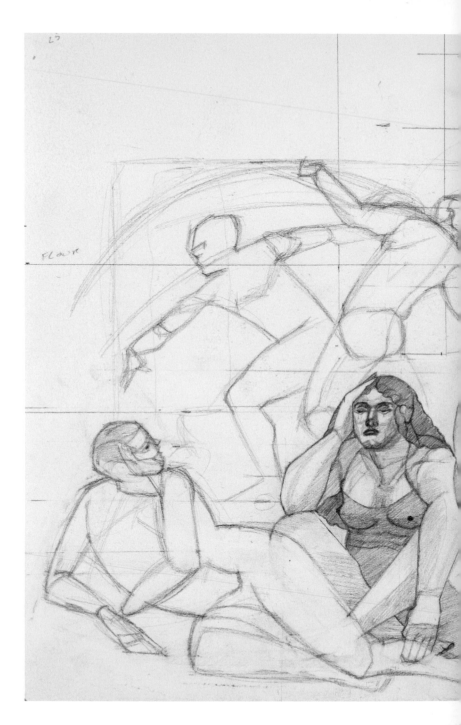

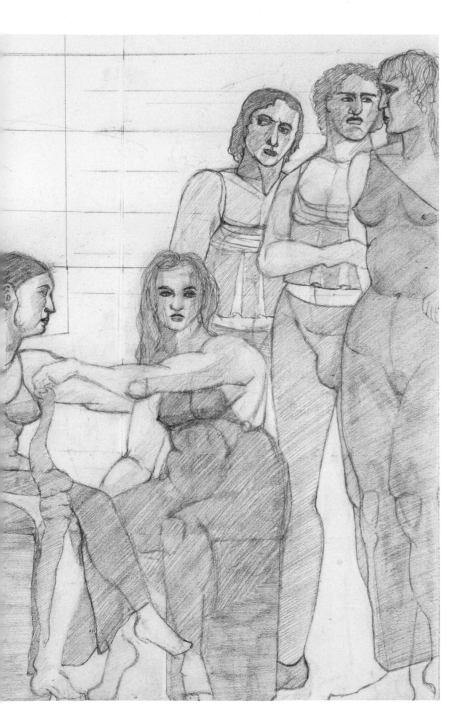

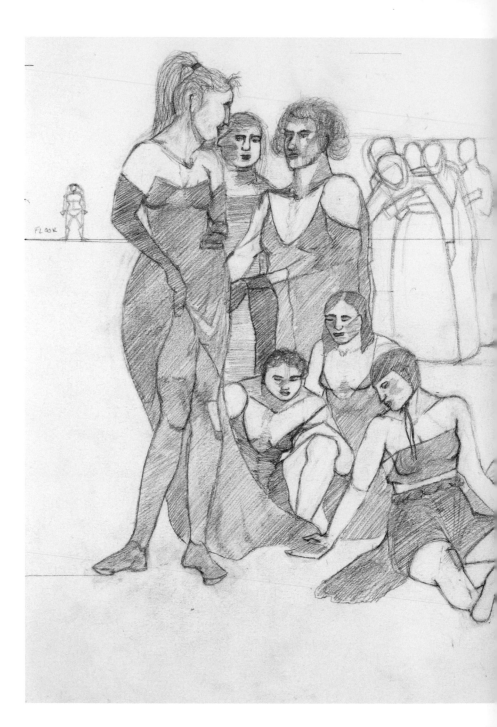

FLOOR

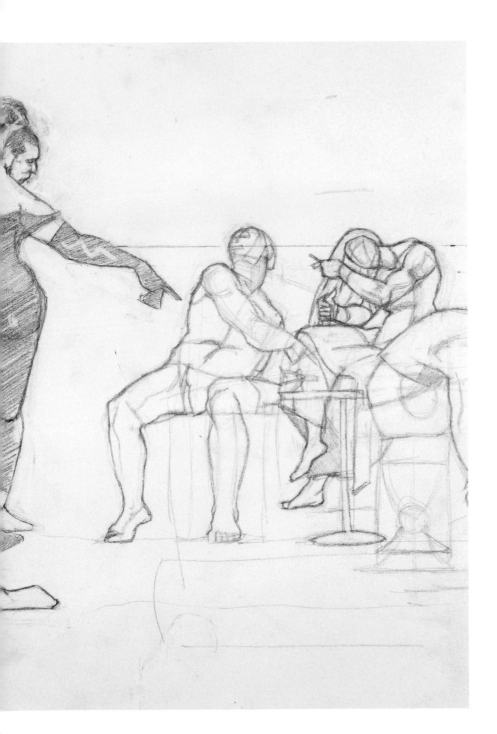

260

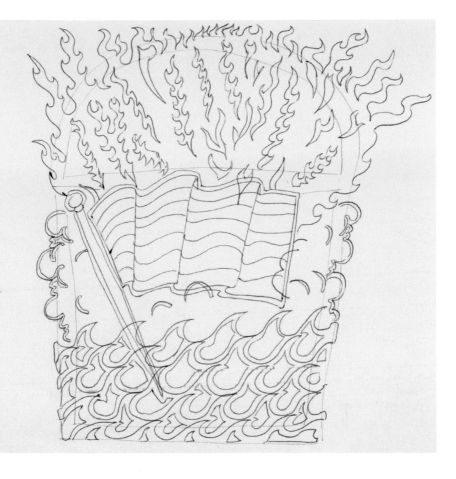

FLOOR

longer torso

Reduced smaller
legs

more compact

Smaller
head

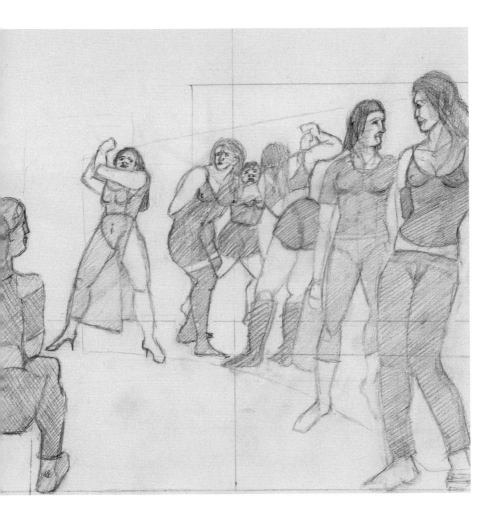

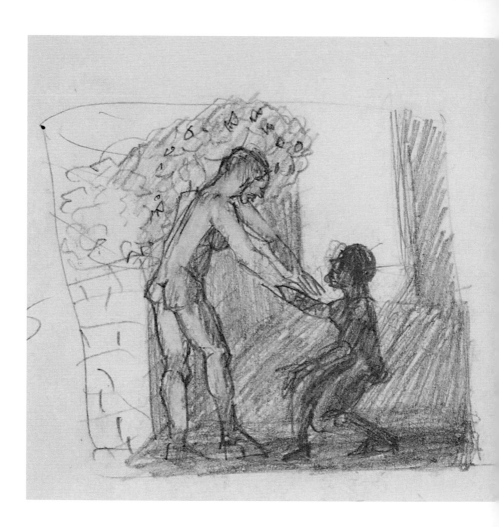

fuel tank

MUM

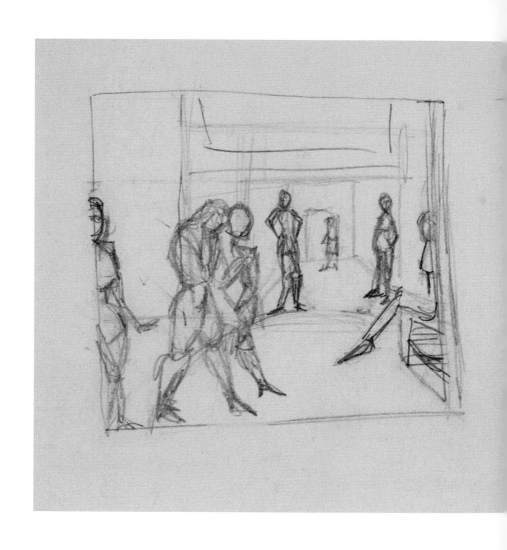

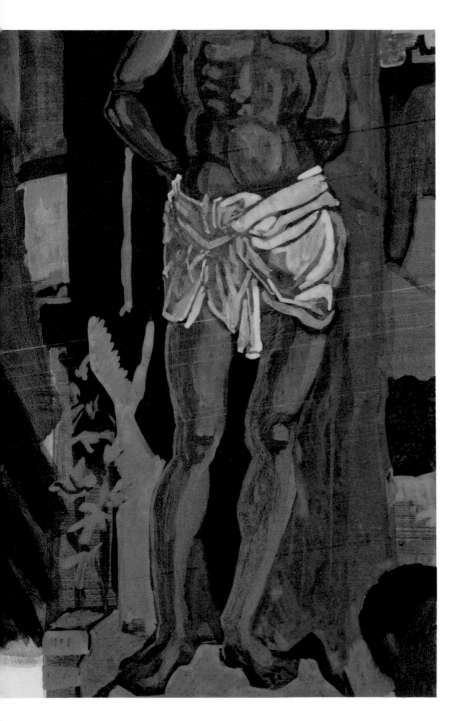

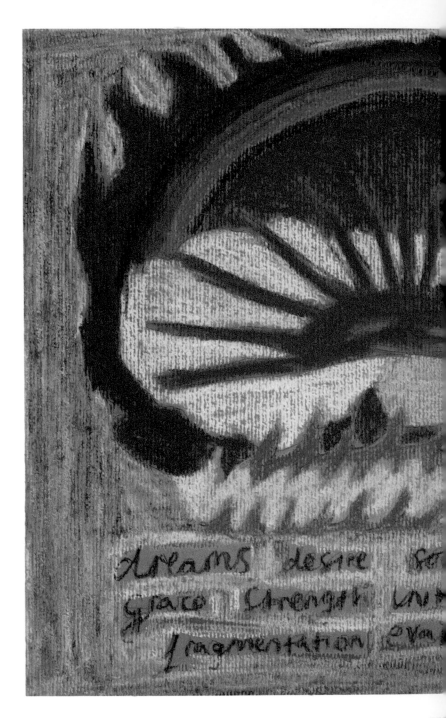

II.

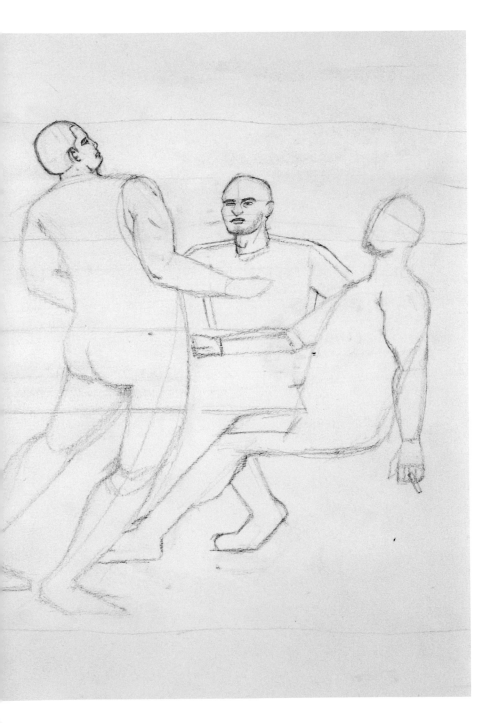

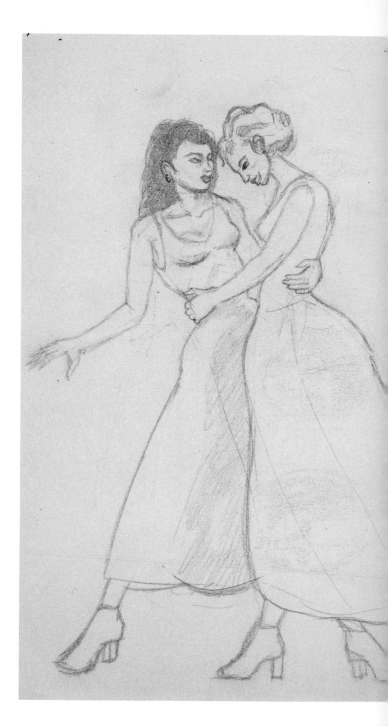

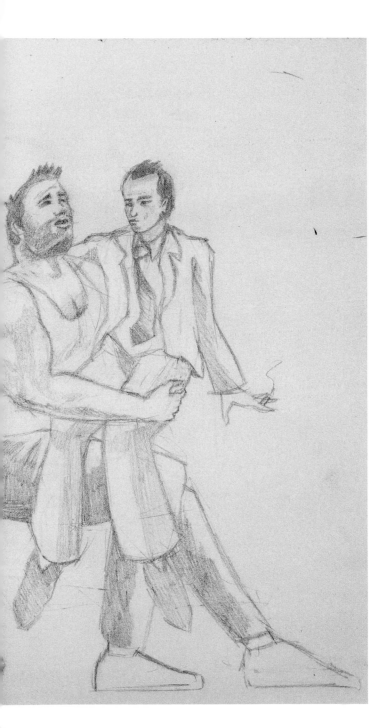

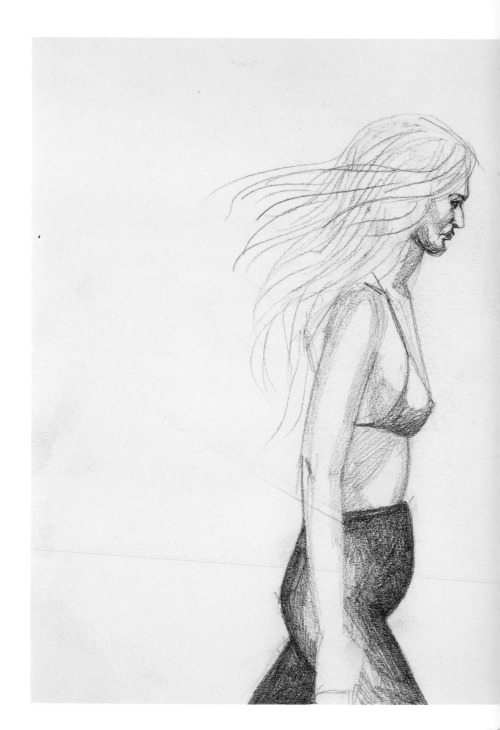

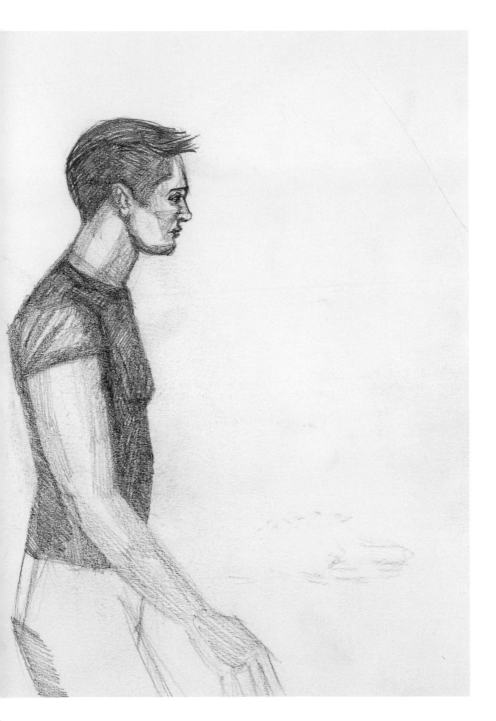

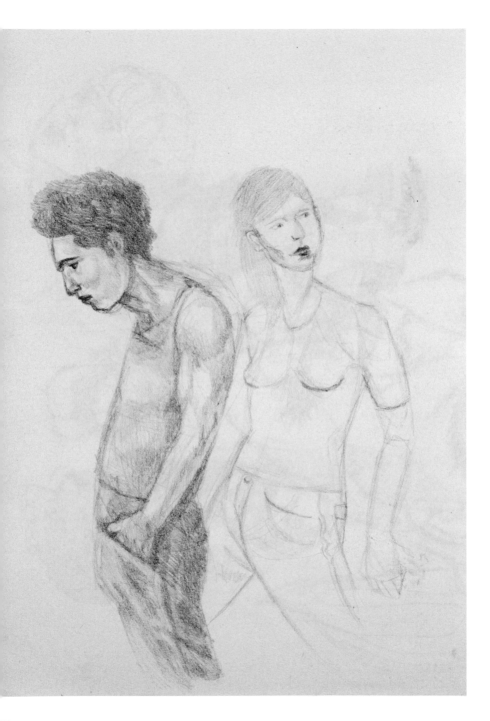

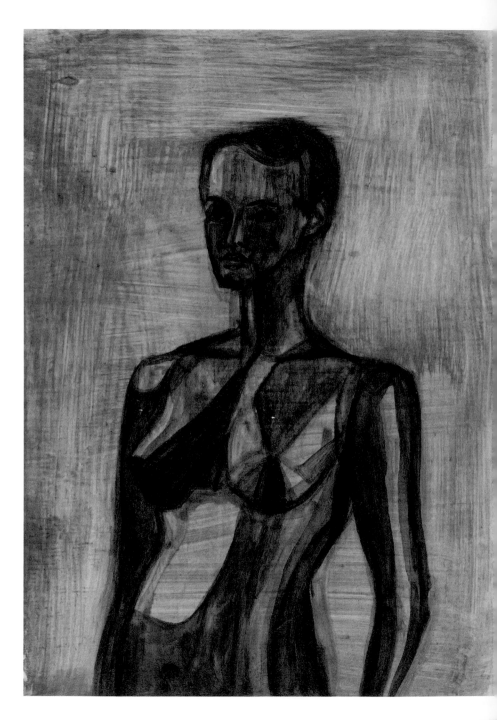

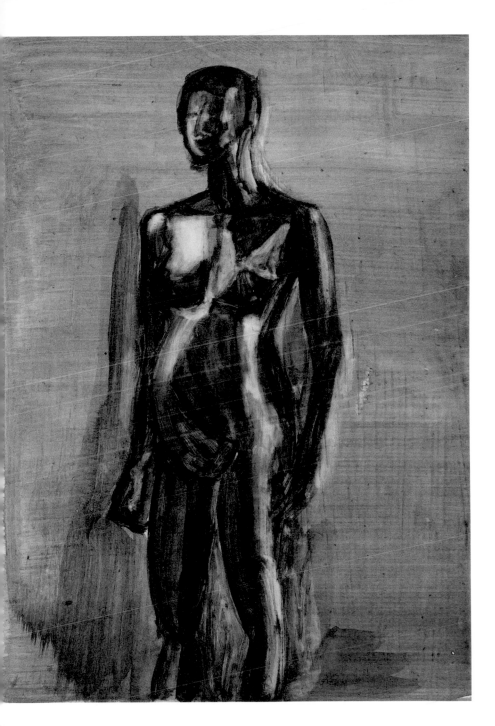

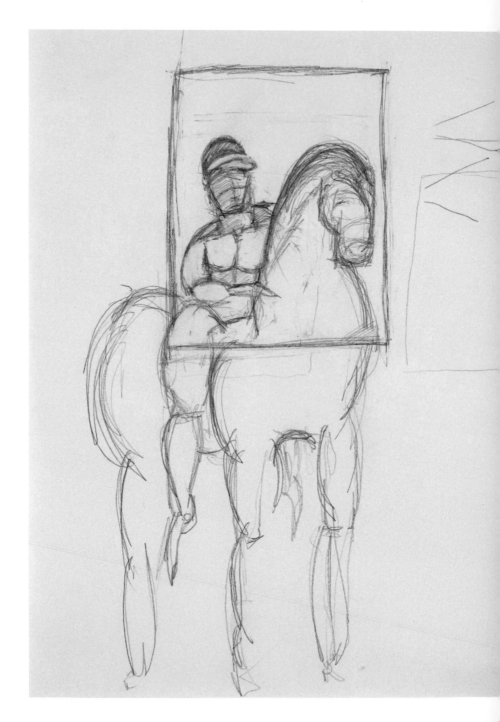

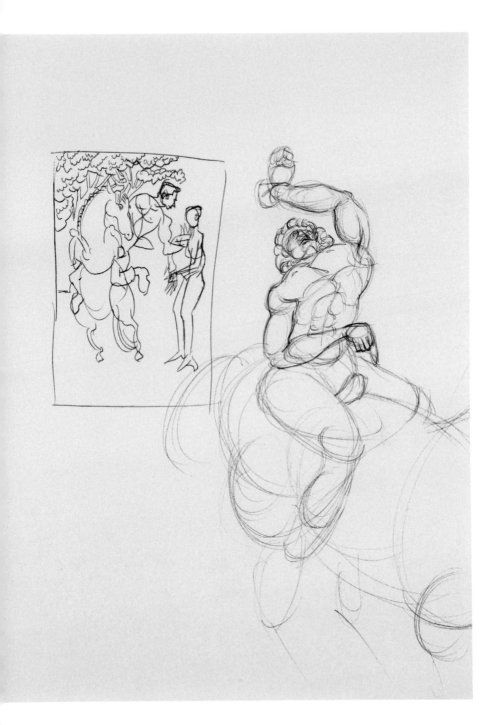

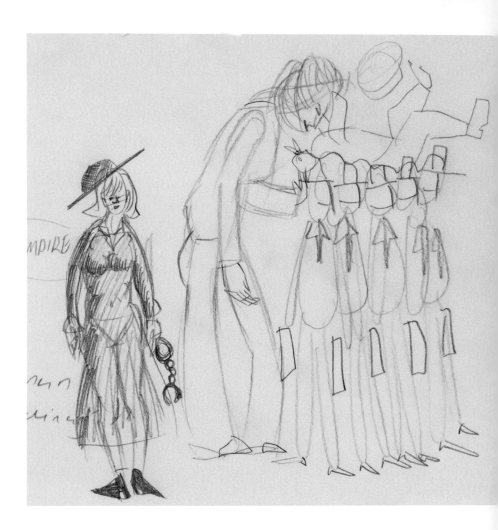

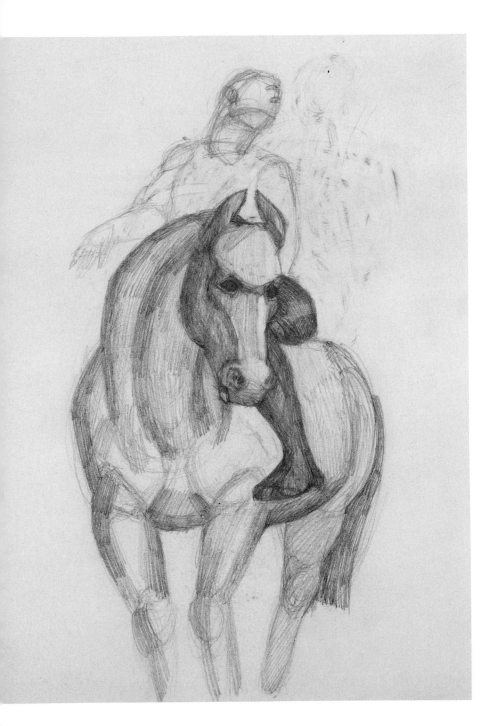

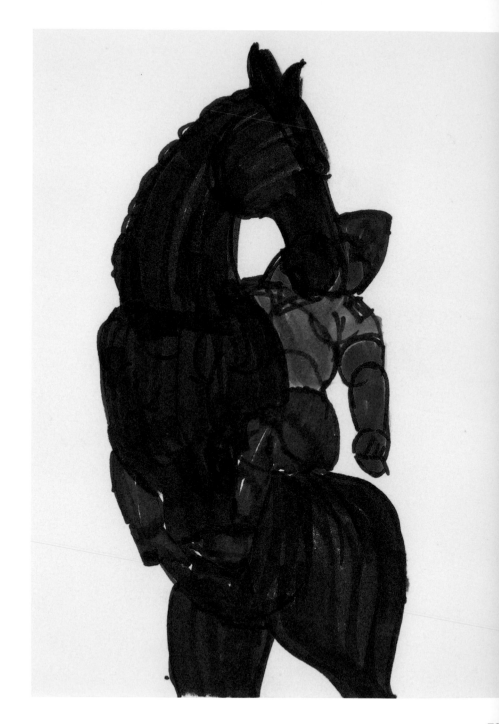

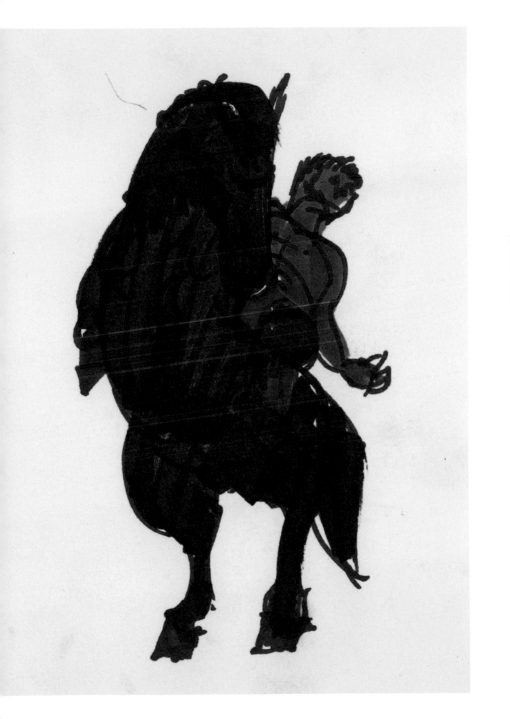

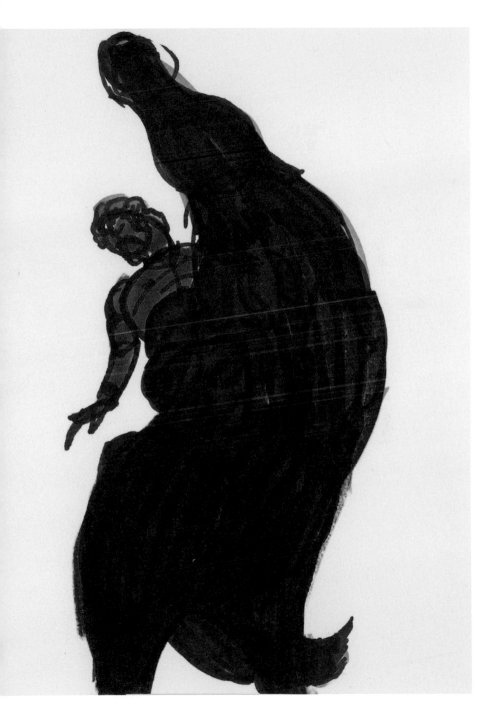

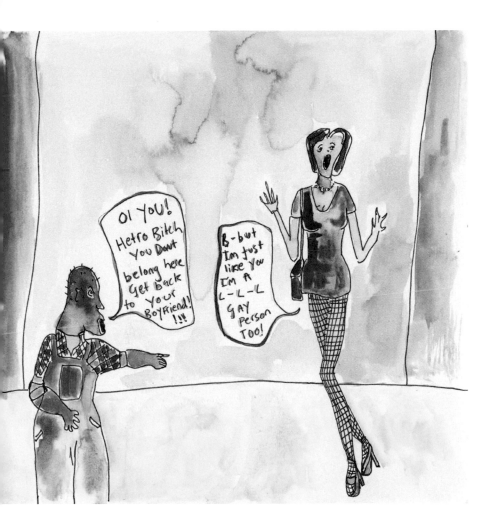

III.

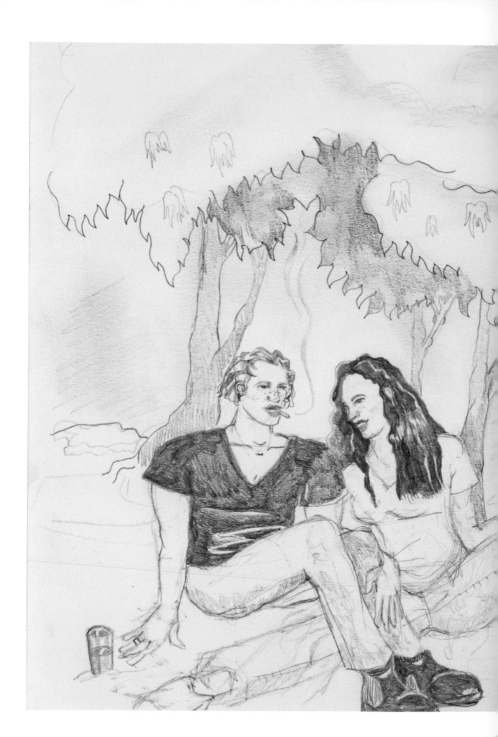

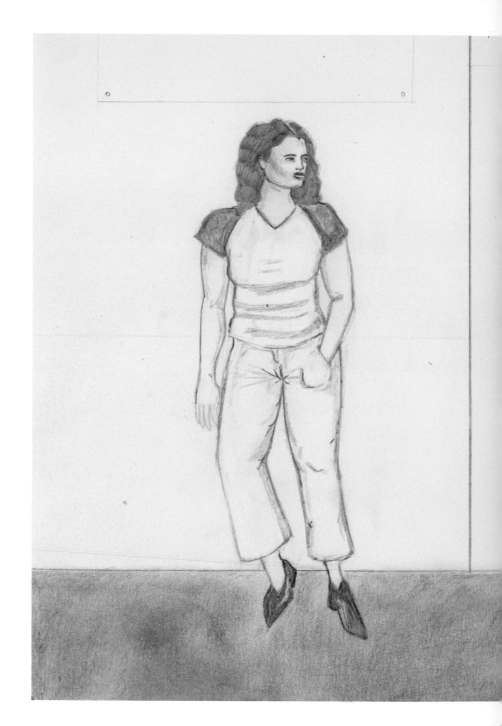

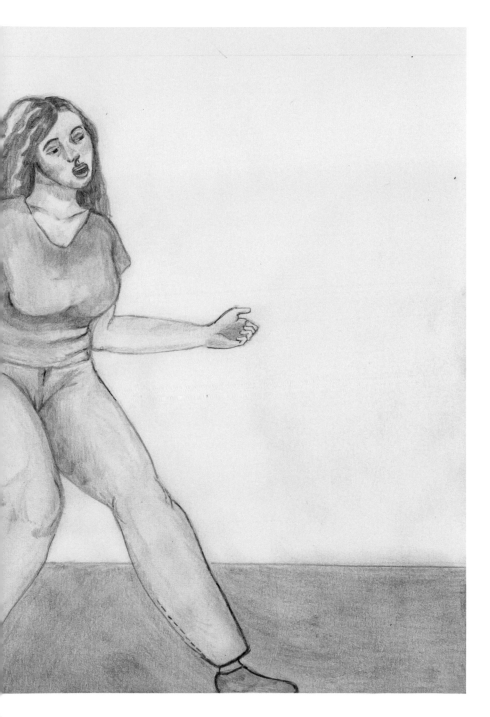

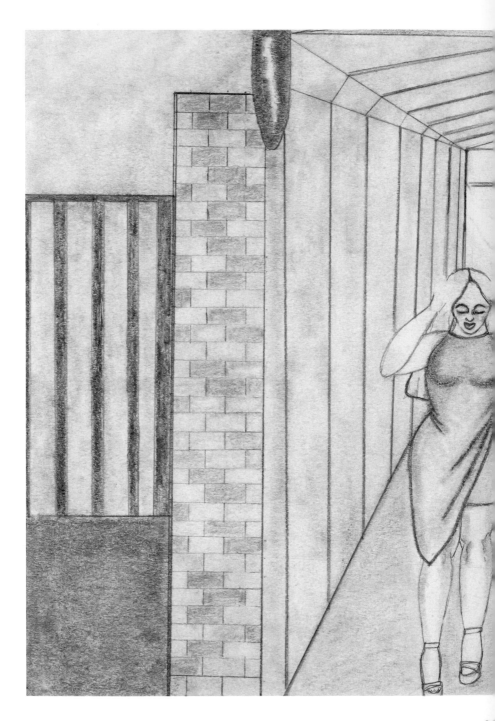

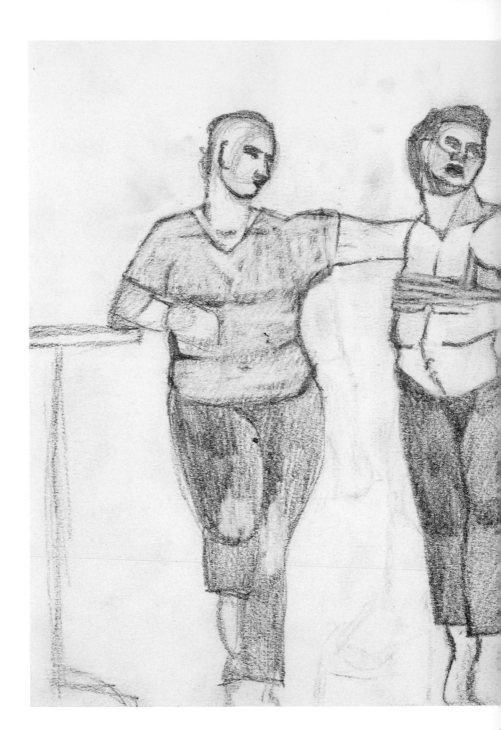

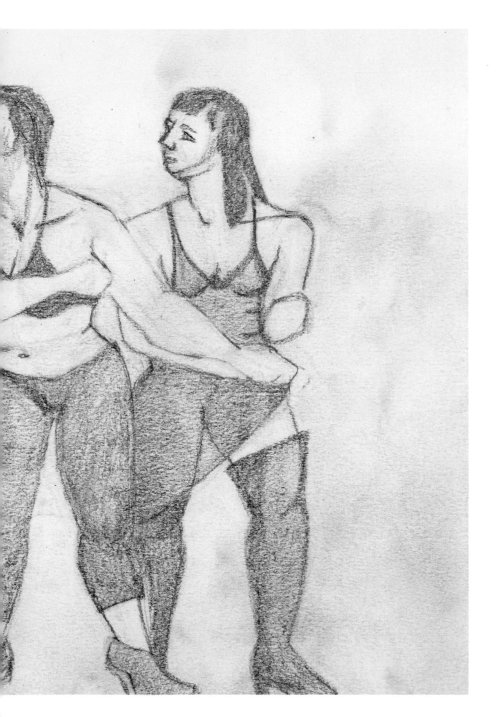

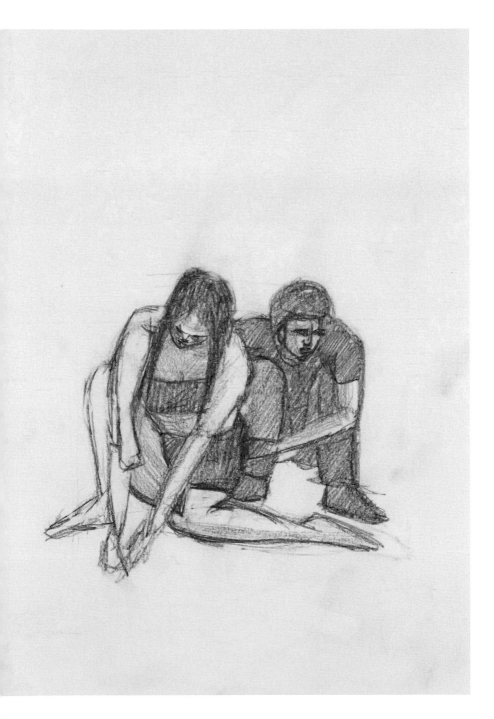

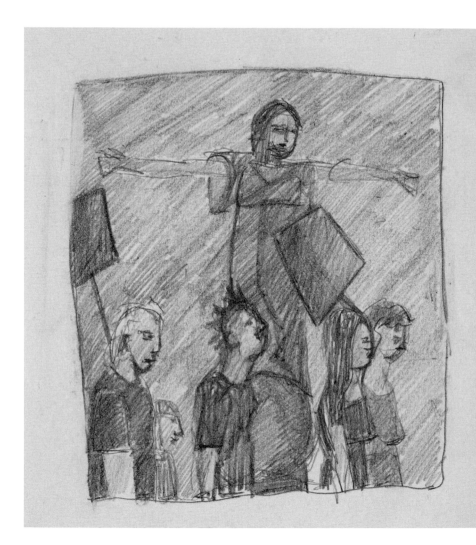

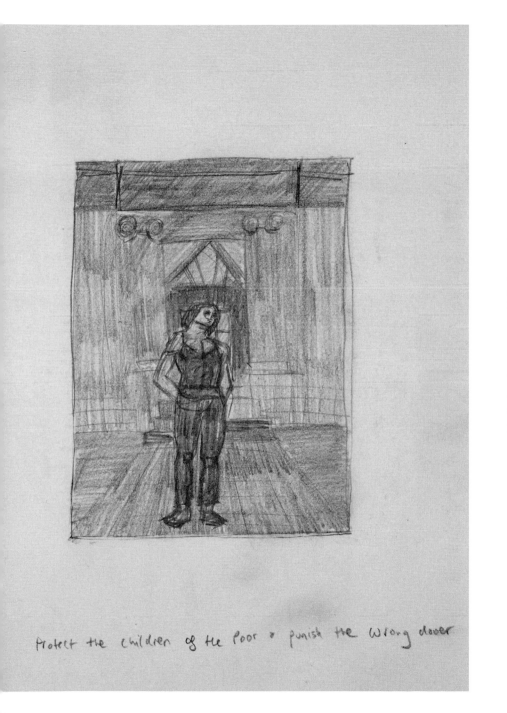

Protect the children of the Poor & punish the wrong doer

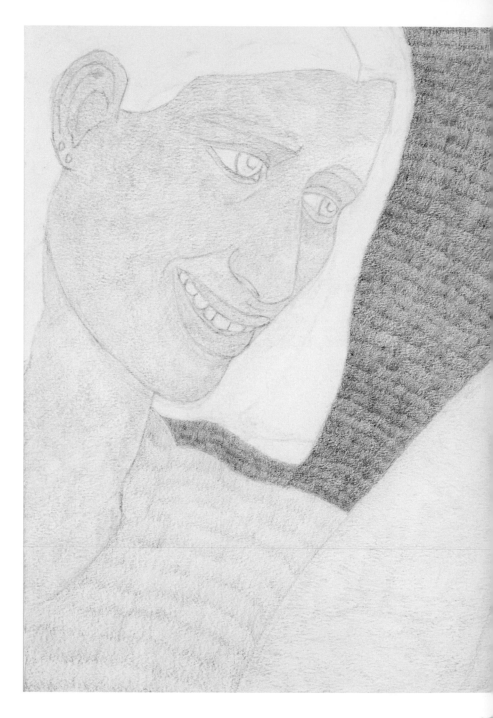

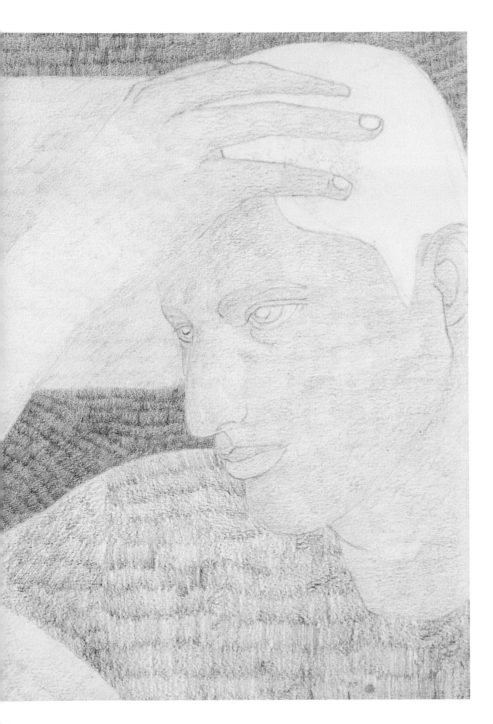

LEO BERSANI

Born 1931 in the Bronx, New York, USA, Leo Bersani was an American academic known for his contributions to gay studies and French literary criticism. He taught at the University of California, Berkley, after time at Wellesley College and Rutgers University. He was elected a Fellow of the American Academy of Arts and Sciences in 1992. Among his most famous writings are the 1987 essay 'Is the Rectum a Grave?', a powerful meditation on how sex shatters the self written at the height of the AIDS crisis, and his 1995 *Homos*, a book-length critique of the then emerging field of queer theory.

HANNAH QUINLAN AND ROSIE HASTINGS

Born 1991 in Newcastle and London respectively, Hannah Quinlan and Rosie Hastings live and work in South-East London. Working across film, drawing, installation, performance and fresco, Hannah and Rosie address the sociocultural and political structures that reinforce conservatism and discriminatory practices within and around the LGBTQ+ community. Their work archives the politics, histories and aesthetics of queer spaces and culture in the West, and proposes strategies for the redistribution of power in relation to gender, class and race.

Quinlan and Hastings are represented by Arcadia Missa in London and Isabella Bortolozzi in Berlin. They are recipients of the 2020 Film London Jarman award and have presented their work at the Centre Pompidou, MOSTYN, Focal Point Gallery, Pinchuk Art Centre, Hayward Gallery, Whitechapel Gallery, ICA London, and the Venice Architecture Biennale, among others. Later this year, they will have solo exhibitions at the Kunsthalle Osnabrück in Germany and Art Now at Tate Britain.

First published in 2022
by Afterall Books in cooperation
with Verlag der Buchhandlung
Walther und Franz König, Köln

Afterall
Central Saint Martins
University of the Arts London
Granary Building
1 Granary Square
London N1C 4AA
www.afterall.org

Afterall is a Research Centre of
University of the Arts London,
located at Central Saint Martins

Editors
Elisa Adami
Amber Husain
Mark Lewis

Project Coordinator
Camille Crichlow

Associate Director
Chloe Ting

Editorial Director
Mark Lewis

Series Design
Pacific
Elizabeth Karp-Evans
Adam Turnbull
www.pacificpacific.pub

Printed and bound
die Keure, Belgium

ISBN 978-3-7533-0239-3

Germany, Austria, Switzerland /
Europe Buchhandlung Walther König
Ehrenstr. 4,
D - 50672 Köln
Fon +49 (0) 221 / 20 59 6 53
verlag@buchhandlung-walther-koenig.de

United States and Canada
D.A.P. / Distributed Art Publishers, Inc.
75 Broad Street, Suite 630
USA - New York, NY 10004
Fon +1 (0) 212 627 1999
orders@dapinc.com

Outside the United States and Canada,
Germany, Austria and Switzerland by
Thames & Hudson Ltd., London
www.thamesandhudson.com

Published by arrangement with
The University of Chicago Press

Other titles in the series:

Visual Pleasure and Narrative Cinema
Laura Mulvey / Rachel Rose

Can the Subaltern Speak
Estefanía Peñafiel Loaiza /
Gayatri Chakravorty Spivak

The Everyday and Everydayness
Henri Lefebvre / Julie Mehretu

Art on the Frontline:
Mandate for a People's Culture
Tschabalala Self / Angela Y. Davis

Of Our Spiritual Strivings
Christina Quarles / W.E.B. Du Bois